Felt Pen & Watercolor

By Duane R. Light

Preface

This book deals primarily with the combination of felt pen and watercolor. Felt pens are relative newcomers on the art scene; they are produced in different forms, with waterproof or water-soluble inks and wide, fine, or ultra-fine points. These choices offer many challenges (as do all art media).

On the other hand, watercolor has been on the art scene for hundreds of years; though it has only been in recent years that it has become such a popular, exciting, major medium.

Used together, felt pen and watercolor offer unlimited possibilities. However, it is impossible to work on a two-dimensional surface without being concerned with more than just the media and techniques. Some of these other factors, such as drawing, composition, value, overlap, configuration, counterchange, relationships, and color, will also be covered in this book.

No matter which medium (or media) you choose, the basics are the same. The instruction included here should encourage you to put forth your best effort with each piece you begin. Remember, the best way to learn is to paint, paint, paint!

Thanks to my wife, Fran, for her patience and help.

Contents

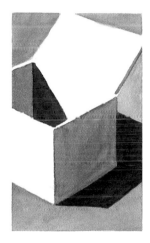

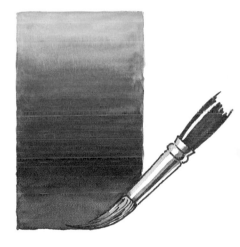

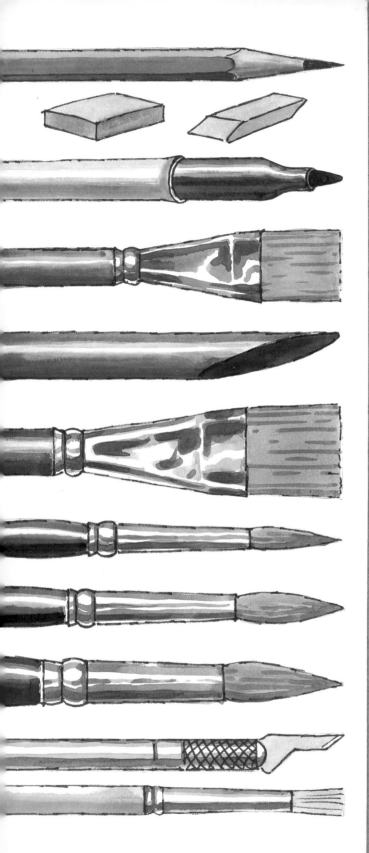

Materials

PENCILS
Use pencils with graphite hardness of HB; harder leads may damage the watercolor paper.

ERASERS
A kneaded rubber eraser is used for pencil; an ink eraser is used to remove areas of watercolor or to soften values.

FELT NIB PENS
Buy only waterproof felt pens (black and brown are the most versatile colors). A fine-point pen like the one shown is a good choice. Experiment with several different styles, and then use the type(s) you prefer.

BRUSHES
Purchase good quality synthetic-fiber watercolor brushes: 1" and 1/2" flats (one with a chiseled handle for scraping out branches, etc.), a #6 or #8 round for detail work, and #12 and #16 (or larger) rounds with good points for laying down large amounts of color.

ART KNIFE
An art knife with a blade like the one shown here can be used to scratch out highlights.

STENCIL BRUSHES
Stiff hog-hair stencil brushes in various sizes (1/8", 1/4", and 1/2") are used to remove color, even down to the white paper, if necessary.

DRAWING BOARDS

Several different types of boards are available. I use 3/8" plywood cut to various sizes. If the board is cut to fit the paper, you can use four clips to paint without prestretching the paper. When the paper gets wet and begins to buckle, loosen the clips one at a time, pull the paper taut, and reclip.

PAPER

Good quality 140 pound rough watercolor paper is recommended. It is most economical to buy 22" x 30" sheets and cut them to size.

MASKING FLUID

There are several brands of masking fluid on the market; choose one of good quality. However, if your paper is of poor quality, its surface will lift when the masking fluid is removed. Note: A rubber cement pickup is best for removing the mask.

PAPER TOWELS / TISSUES

Paper towels and facial tissues are used for creating texture, lifting color, wiping brushes, and cleaning up.

WATER CONTAINERS

In the studio, use a ceramic crock large enough to hold a quart of water and heavy enough not to slide around or turn over when you clean a brush vigorously. For working on location you will need a jar with a lid.

PAINTS

Transparent watercolors in tubes are recommended because they are both brilliant and easy on brushes. There are many different brands on the market; professional grade paints are expensive, but worth the extra cost. Shop around and buy the largest tubes available.

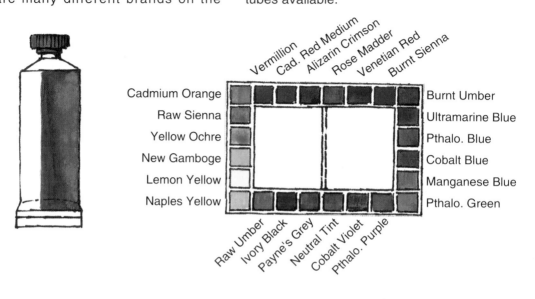

Vermillion · Cad. Red Medium · Alizarin Crimson · Rose Madder · Venetian Red · Burnt Sienna

Cadmium Orange — Burnt Umber
Raw Sienna — Ultramarine Blue
Yellow Ochre — Pthalo. Blue
New Gamboge — Cobalt Blue
Lemon Yellow — Manganese Blue
Naples Yellow — Pthalo. Green

Raw Umber · Ivory Black · Payne's Grey · Neutral Tint · Cobalt Violet · Pthalo. Purple

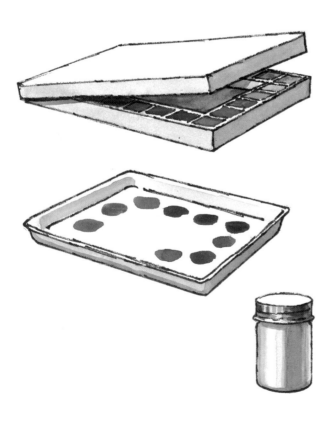

PALETTE

Choose a palette that has a lid. (Watercolor paints are expensive and the lid will keep them fresh and usable longer.) The palette should also have enough wells to hold all of your colors, as shown above. The center divider allows you to keep warm grays on one side and cool grays on the other side. A butcher's tray or a cake pan also work well.

OPAQUE WHITE

Opaque white correction fluid ("whiteout") made especially for artists is used to cover felt pen mistakes. There are several brands on the market; ask your art supply dealer to recommend one that will cover the permanent felt pen and not turn yellow with age.

STUDIO SETUP

In the studio, I usc a drawing table tilted at 15 degrees so I can work either standing or sitting (I prefer standing). I use a French easel for painting vertically both in the studio and on location. In the studio, it allows me to put a mat on a piece and evaluate—often from a distance. Working vertically allows more freedom of arm and body approach, and, when standing, I can work on the entire surface and easily see what is happening. North light is best; if you use fluorescent light, get the kind that is balanced for daylight. I use a taboret with rollers so I can keep my materials somewhat organized and close at hand.

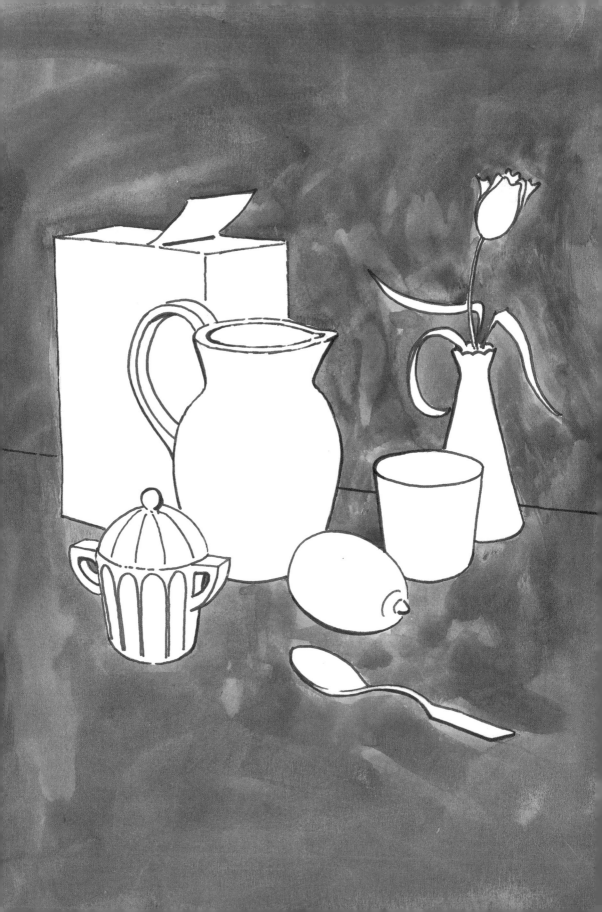

Basics

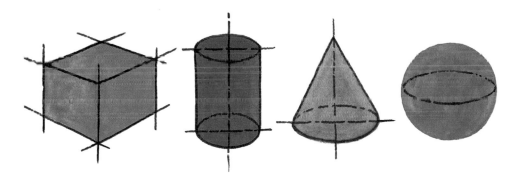

Drawing is one of the basic principles dealt with in this chapter, but there are many additional elements. Following are some of the things to consider when painting:

Concept	Color	Space
Composition	Texture	Mood
Drawing	Warm/Cold	Wet/Dry
Shapes	Contrast	Dominance
Values	Balance	Scale

Note: The elements above are just a few guidelines to success. They are not meant to suggest that you should work within a particular framework when painting—nothing should interfere with the creative process! Artist Phil Dike once said, "A painting is not a painting when it *looks* like something; a painting is a painting when it *feels* like something."

THE CUBE

A cube is a solid form made up of six square sides. View the cube from all angles and learn how to draw it from many different positions. Begin by drawing the straight vertical line closest to you. Then draw lines that represent the horizontal top edges of the cube. These start at the vertical and recede into the picture to vanishing points on the horizon, creating the illusion of depth. Repeat this step from the bottom, extending the lines toward the same vanishing points created by the top lines. Then draw the remaining vertical lines. When using perspective, vertical lines will remain vertical unless the angle of view is changed to either very high (from the top of a tall building looking down) or very low (on the ground looking up). Keep perspective accurate enough for visual acceptance and viewer believability.

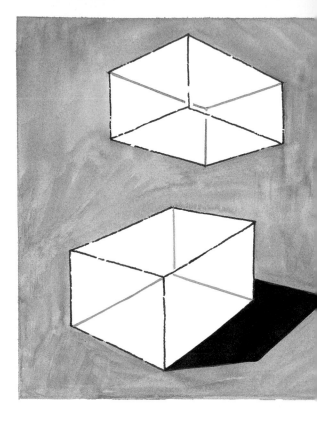

THE CYLINDER

A cylinder is a form with two equal, parallel, circular ends. When viewed at an angle, the circles become ellipses. Draw various sizes of cylinders, both standing and laying down; draw them from various angles. Carefully observe the ellipses for their relationships to one another and the straight lines to them. Notice how the distant ones become smaller. Be aware of the vanishing points. First draw the top ellipse, then the sides, then the bottom ellipse. Practice drawing cylinders using cans, bottles and jars for reference. By practicing in this manner, cylinders should not be a problem when encountered in a subject.

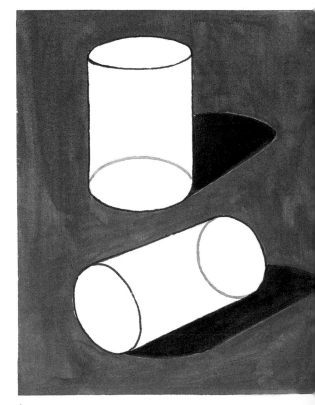

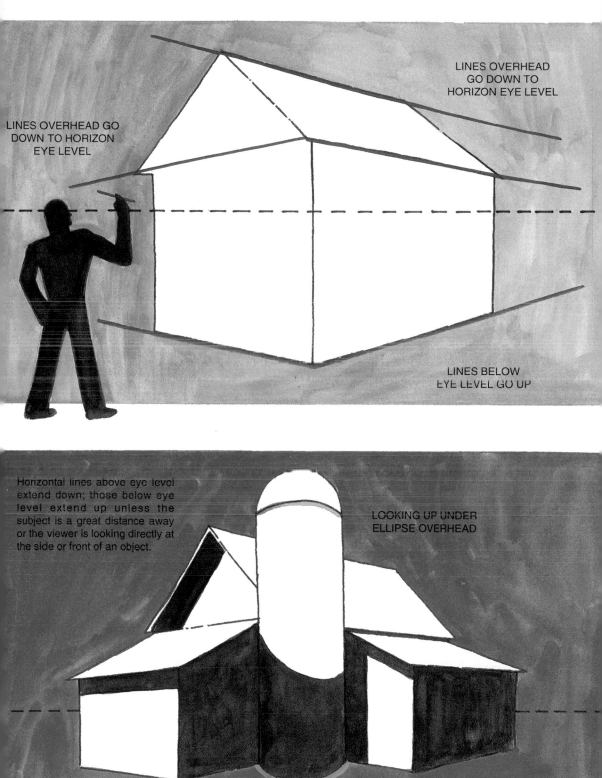

LINES OVERHEAD
GO DOWN TO
HORIZON EYE LEVEL

LINES OVERHEAD GO
DOWN TO HORIZON
EYE LEVEL

LINES BELOW
EYE LEVEL GO UP

Horizontal lines above eye level extend down; those below eye level extend up unless the subject is a great distance away or the viewer is looking directly at the side or front of an object.

LOOKING UP UNDER
ELLIPSE OVERHEAD

LOOKING DOWN
ON ELLIPSE
BELOW EYE LEVEL

THE CONE

A cone is a solid form that has a circular base and an apex, or point, on the opposite end. The apex and base are joined by straight lines. The curve of the base circle gives the cone its shape. When viewed from an angle, the base becomes an ellipse—the most important element.

First draw the ellipse. Next, draw a straight line from the center of the ellipse to a point that will become the point of the cone. Establish the length of this line by judging the length of the cone compared to the width of the base. Now draw the sides of the cone by drawing lines from the perimeter of the ellipse to the point of the center line. Practice drawing cones using objects around the house. Always observe the relationship of center lines and ellipses.

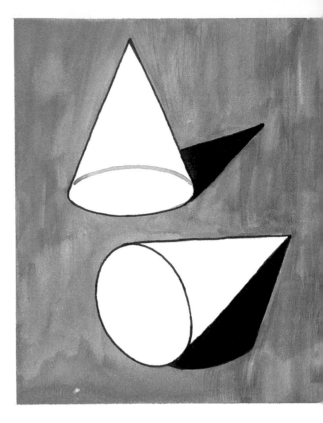

THE SPHERE

A sphere is a round object with a surface that is equally distant at all points from the center. A sphere seems simple, but keep in mind that it has three dimensions; a circle is flat, a sphere is not. Spheres should be drawn freehand and then tightened later. Don't labor over them.

Place objects of all four basic shapes on a flat surface out in the sun. Draw during morning, midday, and late afternoon sun for a variety of cast shadows.

Note: The shadow of a sphere will always appear as an ellipse when cast on a flat surface if the flat surface is viewed from an angle such as a tabletop.

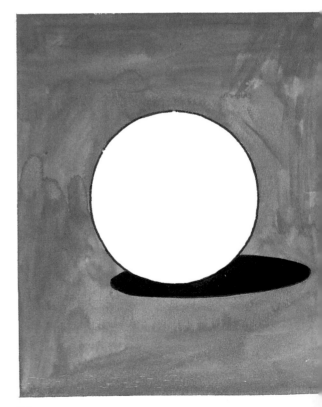

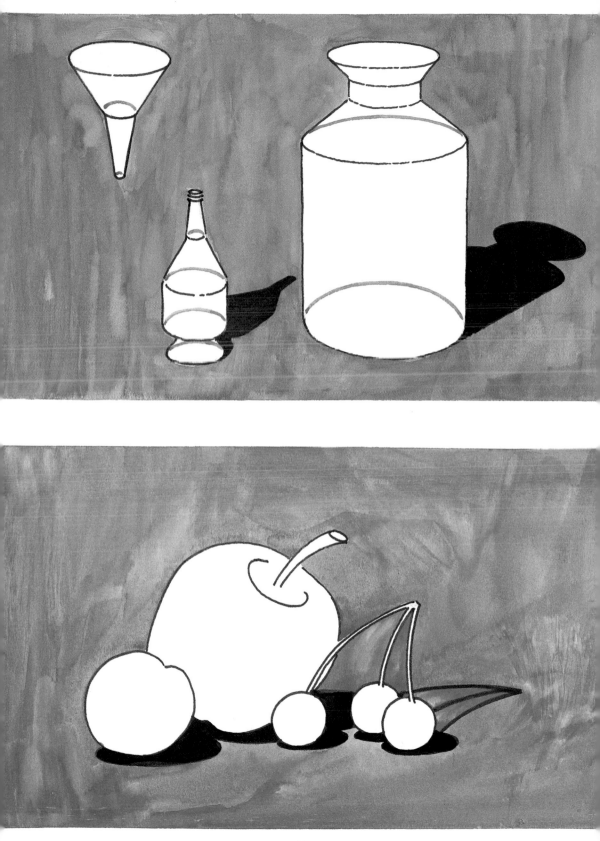

15

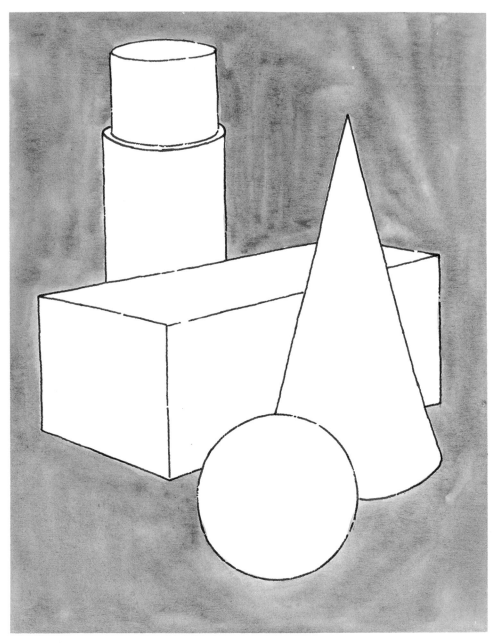

These four objects have been placed on a flat surface in such a manner that each shape overlaps the next. **Overlap** is essential for good visual communication. The brain has no problem understanding these relationships, though they are just simple shapes at this time. The configuration of the shapes should be interesting, and their relationship to the picture plane should be visually satisfying: the distance from the top shape to the top of the paper, from the bottom shape to the bottom of the paper, and from the outside edges of the objects to the sides of the paper. This, either consciously or unconsciously, is composition. Here we have a positive shape and a negative shape within a rectangle.

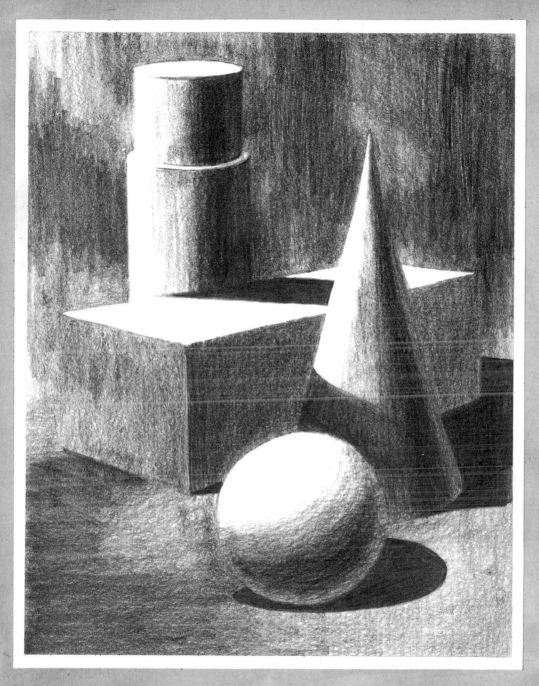

The challenge is to begin with an arrangement (composition) of shapes on a flat surface, and then use value to integrate them with the background, producing an aesthetically satisfying whole. First, establish your light source. The light source will affect the lights, shade, and shadow (this is how we see). Changing the direction of the light source completely changes the light pattern or design. In the example, the light is coming from the upper left. Following the idea of light against dark, establish value in the background (or negative shape). In some places it will have great contrast; in other places it will be lost or there will be no separation. This is called "lost and found."

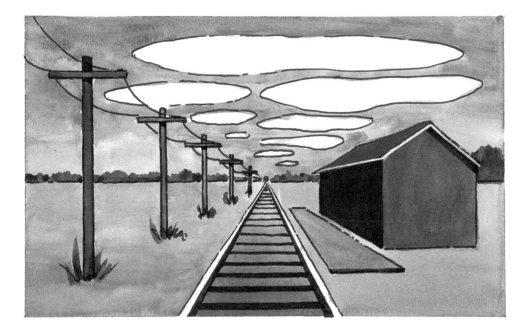

ONE-POINT PERSPECTIVE

When you stand and look directly ahead, focusing on one point on the horizon, such as the red dot in the railroad scene above, your peripheral vision will bring all horizontal lines to that point in relation to one another. The same principal applies to the interior scene below.

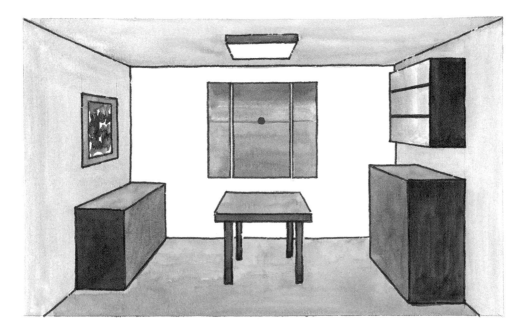

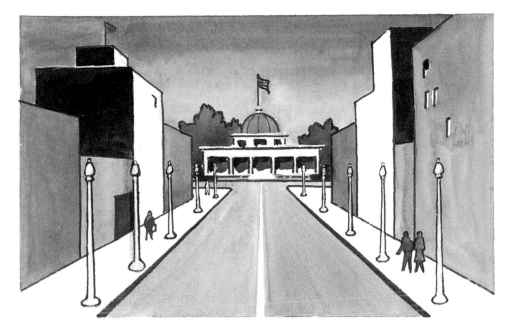

The perspective of a city street scene depends on the angle of view, according to the height of the viewer. For example, the viewer can be looking out of a hotel window (high angle) or standing in the middle of the street (low angle). The vanishing point will be directly ahead at eye level and everything else will seem to point there. Notice that even the peaks of the roofs form a directional line to the horizon.

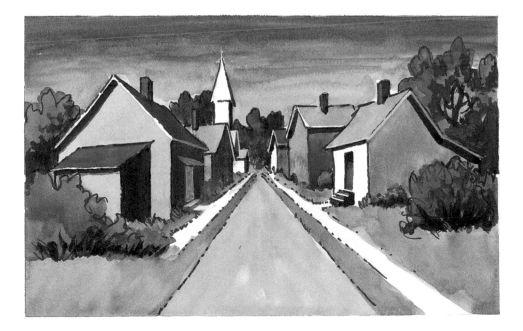

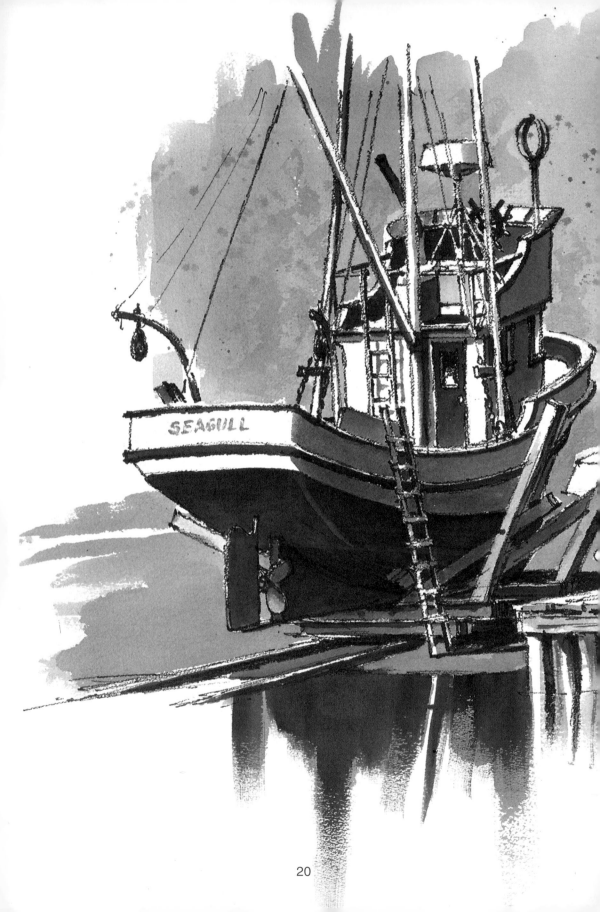

Drawing and Composition

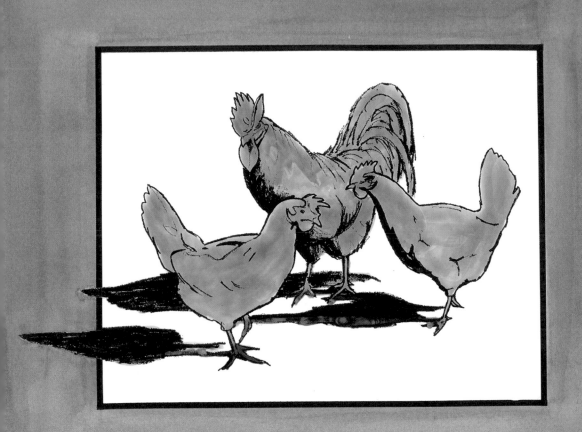

ORGANIZING AN IDEA

This chapter will deal with arrangements and relationships. When one object overlaps another, the resulting outline (shape) is called a configuration. When an object is in front of another object in sunlight, it appears lighter. A power line shown against the sky appears dark, but a power line shown against a dark tree appears light. Scientifically, this phenomenon is called "transposition of value"; in the art world, it is called "counterchange" (see the figures to the left). The chickens and the rooster above are far more interesting as a group (configuration) than as individual shapes. The illustration at right is a good example of an interesting silhouette and counterchange in nature.

Our job as artists is to *see*. There are no perfect compositions in nature. Move things around until they are aesthetically exciting.

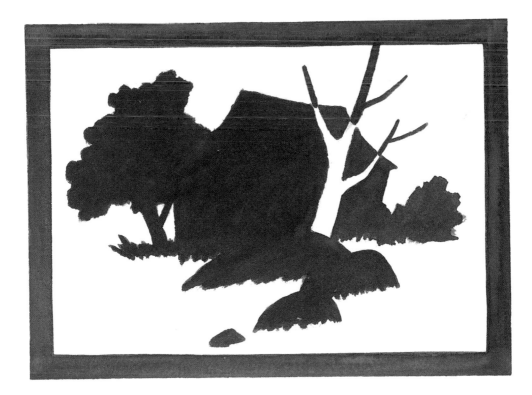

GETTING ACQUAINTED
Try to sketch these common shapes believably. Remember that their proportions, as well as their characters, are important.

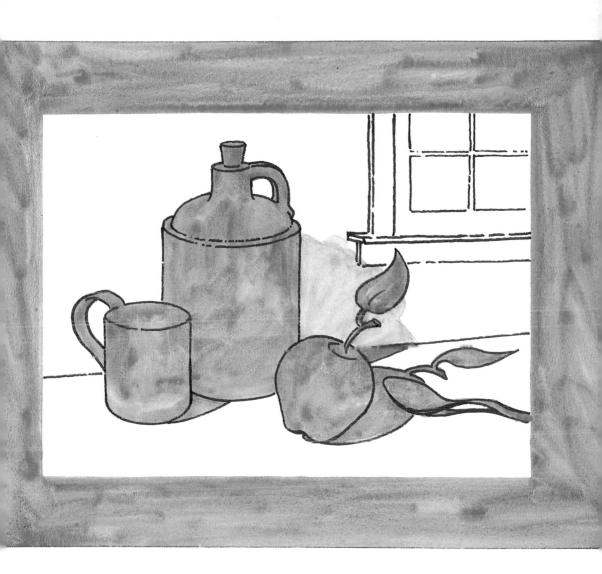

RELATIONSHIPS

We have seen these shapes on their own many times. The challenge is to present them in an exciting way. After becoming acquainted, relationships (composition) become more important. Overlap creates configuration. Move things around until the configuration is interesting; be creative. Adding the window indicates a specific source of light. However, in the studio at night you can have the light coming from any direction you wish, but you must follow through in the final painting. If you are satisfied with the idea and arrangement at this point, chances are that the painting will be successful.

Toys are like people—they have character and gesture. Ask yourself, "Are they brand new or old and worn?" Their proportions, such as size of head to body, etc., are extremely important.

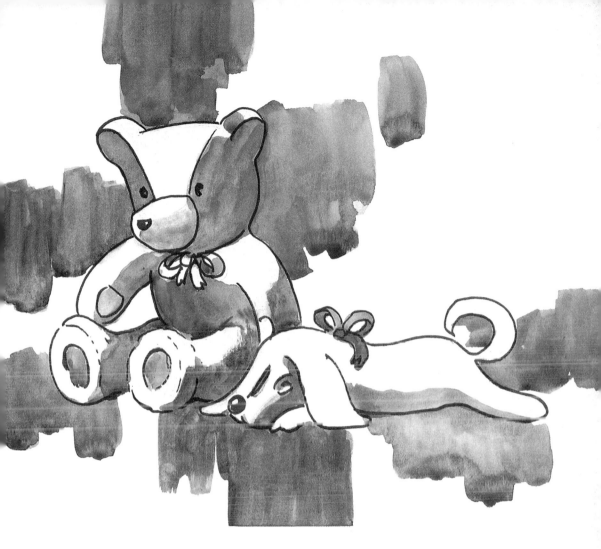

Overlap is important in every arrangement. Move the items around until you are satisfied; experiment. A vignette like the one above may be right for you. In the painting to the right, an environment has been created—the attic where the outgrown toys have been stored.

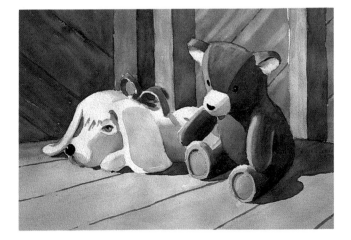

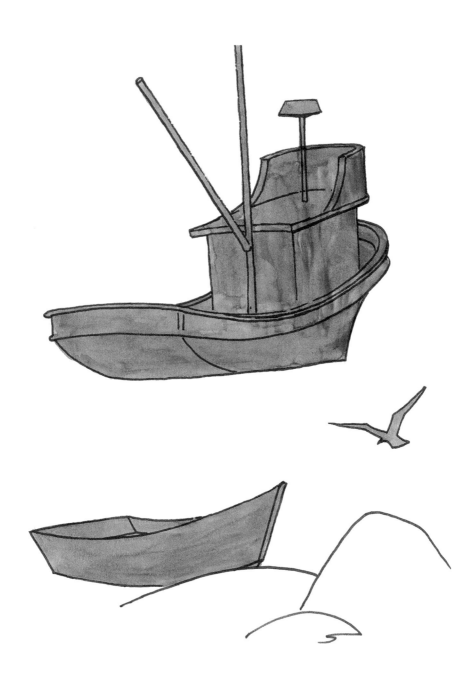

Like all things we paint, the more skill we have handling a subject, the more confident we are when painting. Here are some necessary elements for painting maritime scenes: boats, water, land, pilings, seagulls, etc. Boats can be difficult; look at them from different angles; look for different types and sizes, and then, most importantly, practice drawing them.

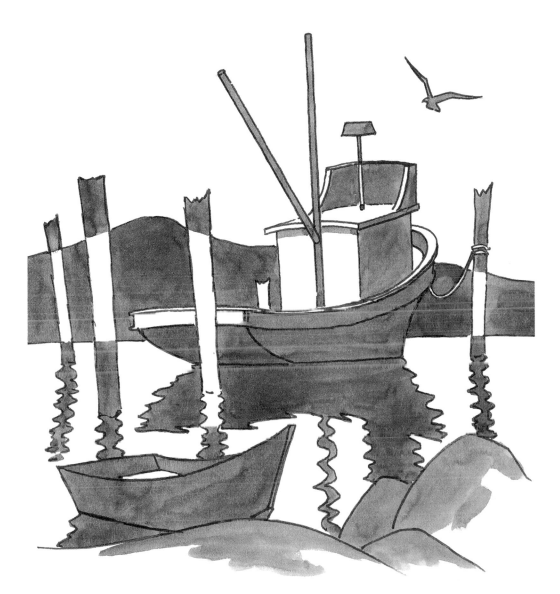

There is a great deal of counterchange in this arrangement. Notice that the pilings appear light against the dark background, but they appear dark against the lighter water and sky. Notice how this gives life to the arrangement. Learn to *see*!

To create more depth and dimension in your scene, paint individual shadows by using a series of washes until the right value is reached. Judge each element against the others in the painting. If the shadows are fairly uniform in value (lightness or darkness) the overall effect is flat. Notice how different shapes create shadows of varying depths.

Shading
A Search for Three Dimensions

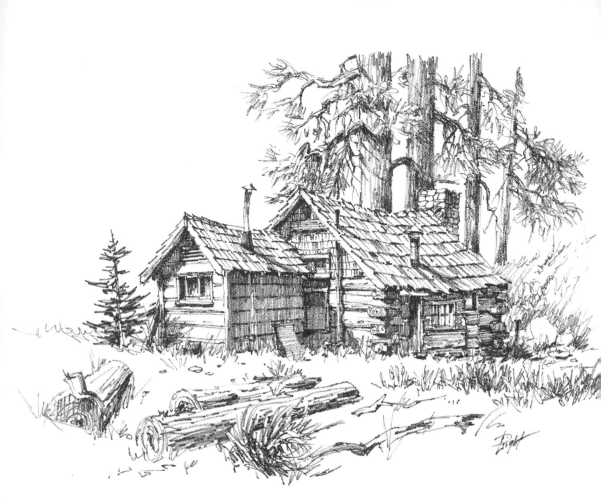

Sometimes the eye is attracted to an object for no apparent reason. It may be an ordinary shape, but something in the way the light is falling on it during the particular time of day and the particular time of year may be presenting an unusual and exciting overall design. In the abstract, shade and shadow can produce a very compelling visual experience. When this happens, immediately take a snapshot to capture the shapes before the light changes—and it will change rapidly. I also like to quickly sketch with the felt pen, as you see here, but even then the magic may disappear before I get it recorded, so I then refer back to the photo. There is no substitute for sketching on location; firsthand information is the best way to get a "feel" for the subject.

STEP 1

Observe the subject from all angles. Then use an HB pencil to sketch it on the watercolor paper. Be sure that you are happy with both the arrangement and the proportions before going on.

STEP 2

When working on location, the light source is pre-determined. In the studio, you must choose the source. Do a quick outline with felt pen. Then, keeping in mind the direction of light, use either very light or no lines on the side of the object facing the light. Also, look for areas in shade and cast shadows.

STEP 3

Carefully observe the shadows, and then complete the drawing by shading on the side away from the light. The shapes in light relate to one another; likewise those in shaded areas. All of these shapes are geometrical and contribute to a unified overall scheme.

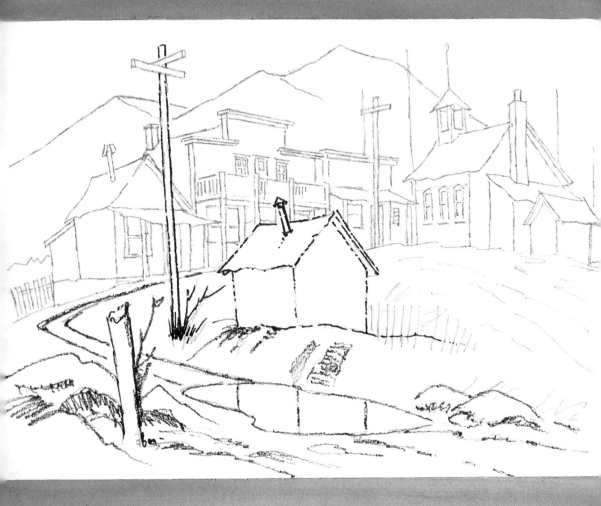

This Colorado ghost town offered a challenge because there are many different materials to present: old wood, stone, and brick, as well as the great number of things in the environment, such as snow, melted snow, trees, mountains, sky, and rock. First, use HB pencil to sketch on the watercolor paper. Place the buildings close together, making sure that the one in front overlaps enough to push the others back. Then, keeping in mind that the light is coming from the left, go over the objects in the foreground with felt pen. Note: Start with the objects in the foreground and work toward the background, because if you inadvertently draw a line through something with the felt pen, it is difficult to repair.

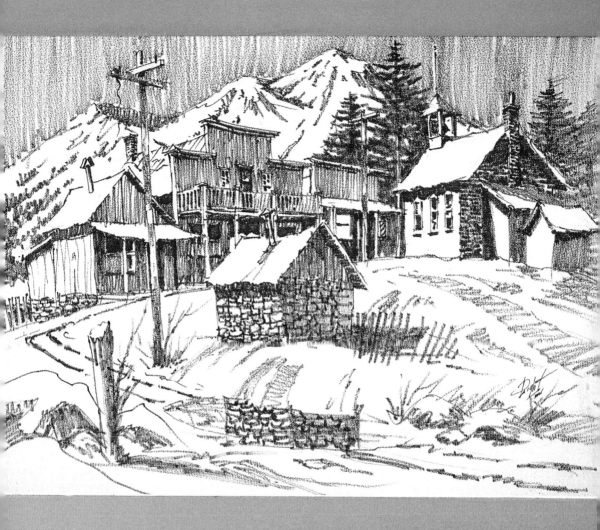

Observe the character of the scene carefully; exaggerate it just enough so the viewer can "feel" it. When making the strokes, follow the direction of the object so the viewer can easily read the surfaces. All shaded areas and cast shadows are filled in by holding the pen at arm's length, like a brush. Don't be afraid to work casually with a felt pen; the effect is more desirable than a very stiff rendering. Finally, place a mat on the work and check it for balance. Does it have a pleasing relationship of black, white, and grays? Don't work too small; this drawing is 22" x 30".

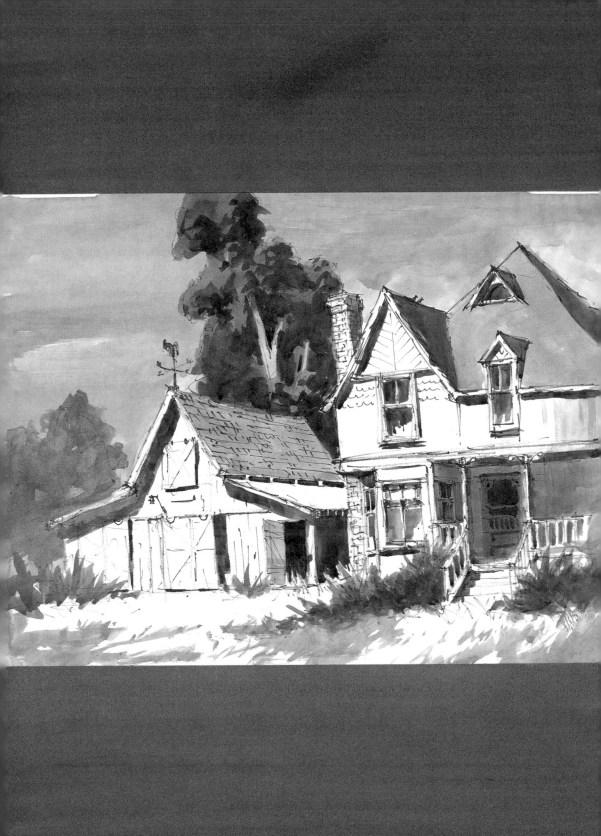

Value

There is an infinite range of greys between white and black (or light and dark). These values define everything we see; color is simply the "icing on the cake." Soft steps between values allow for natural conversation; extreme contrasts allow for shouting or emphasizing a point. Gradation of value allows for either slowing down or speeding up the viewer, or changing the mood. Note the three examples shown here; each has a complete range of light to dark in one color.

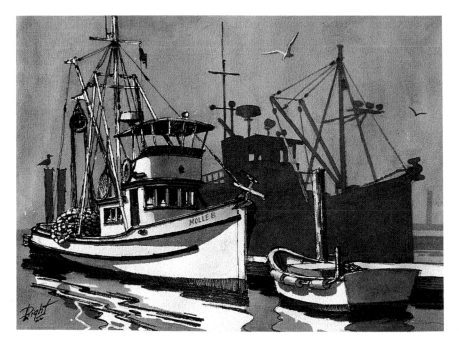

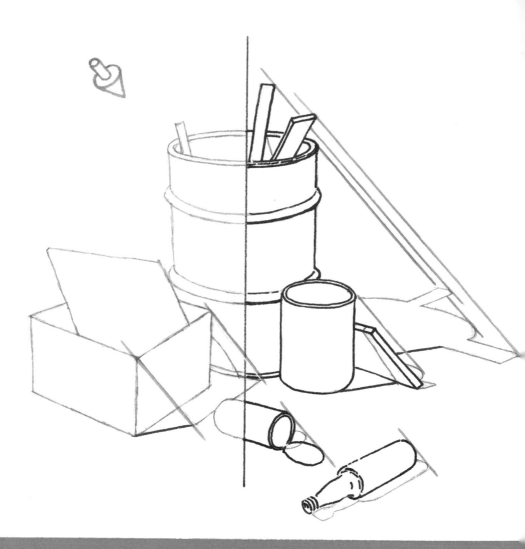

STEP 1

When beginning a sketch like this one, be aware of the three-dimensional aspect of the whole, as well as the light/dark pattern. This can be accomplished by using a big brush to record big shapes in value. Also, for individual shapes, use the pencil to sketch each shape, and then move the shapes around until you are pleased with the proportions and arrangement.

STEP 2

Working from the foreground to the background, begin outlining the objects with felt pen. Then erase all pencil lines except those that indicate shadows. With the light source in the upper left, plot the shadows. Light is straight, so shadows fall across all objects at the same angle. The red lines indicate the direction of the shadows at ten o'clock in the morning from a vertical. Shadows need not be perfect, but they should be believable. Observe the shadows on location, and record them with a sketch or instant photo.

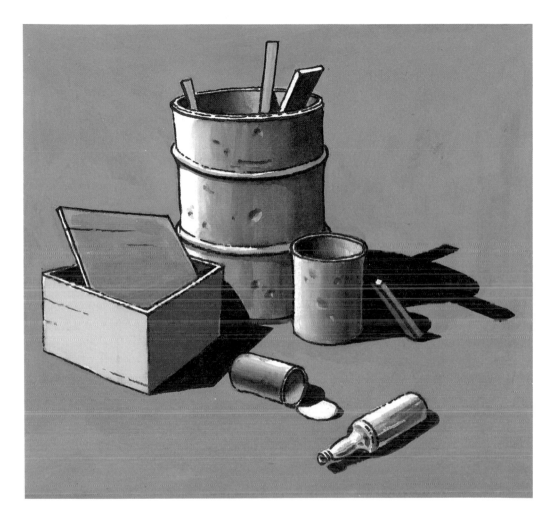

STEP 3

Keep in mind that the light is coming over your left shoulder. Then leaving the top areas white, begin on the left with a heavily-diluted gray (such as payne's gray), and apply a graded wash from light to dark (add more pigment to make the wash darker). The side of the box away from the light should be dark, but not as dark as the shadows.

STEP 4

If a smooth background (no gradation) is desired, cover the whites with masking fluid and let dry. Mix enough paint on the palette to cover the entire area. If you stop along the way to mix more color, a hard edge will form where you stop. Being right handed, I start at the top left and work left to right and top to bottom, moving along at a comfortable speed and overlapping each stroke like mowing a lawn. The last step is to add the shadows (the darkest value).

STEP 1

Use HB pencil to sketch the subject on the watercolor paper.

STEP 2

Go over the drawing with felt pen, and then erase the pencil lines (except those that indicate shadows).

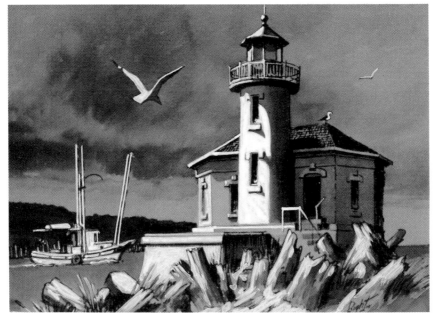

STEP 3

Use masking fluid on the gulls, the masts on the boat, and anything you don't want to paint around. Wash a light gray over everything except the large white areas.

STEP 4

Let each wash dry before applying the next. Allow the sky to dry, then dampen with a brush and clear water before adding the clouds.

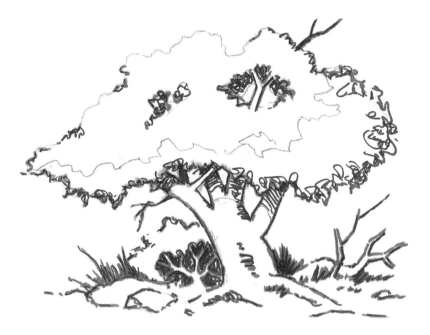

STEP 1
The tree and bushes provide a series of interesting shapes and textures.

STEP 2
Use a felt pen on the shaded side of the foliage. Then draw the trunk and bushes.

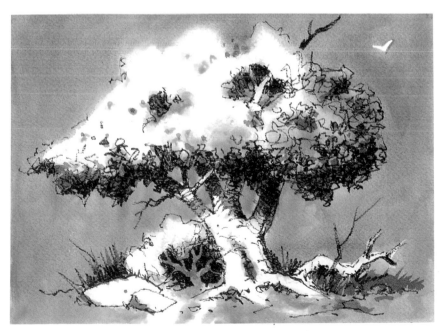

STEP 3
Apply a colored wash (color has value) over everything except those things that are to remain white.

STEP 4
Finally, come back in with the felt pen, strengthening the texture and shapes over the color.

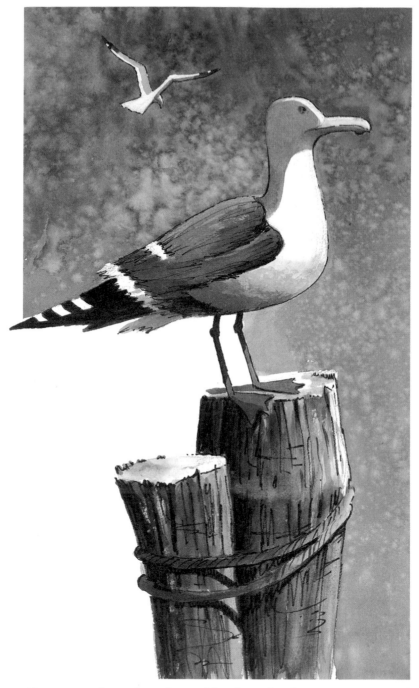

Keep experimenting. A combination of colors, textures, and ideas can be fun and very rewarding: how much pen and where, how much color and where, how much texture and where, etc. These are some of the decisions that are made while painting. (The texture in this piece was created by dripping water into the wet background.)

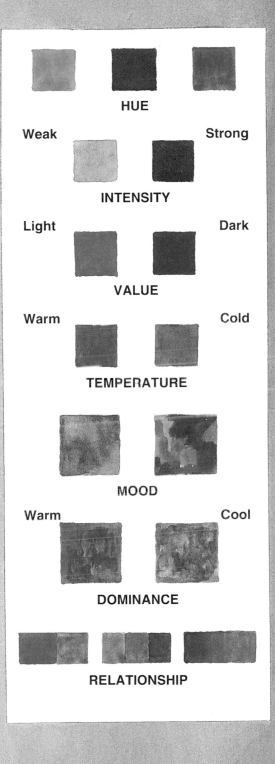

HUE

Weak Strong

INTENSITY

Light Dark

VALUE

Warm Cold

TEMPERATURE

MOOD

Warm Cool

DOMINANCE

RELATIONSHIP

COLOR

The nature of color is such that one must consider every aspect of it. The relationships of warms and cools and lights and darks are extremely important. Be aware that adding water or a drop of any other color will change the intensity (lighter or grayer) of the pure color. Learn to use pigment without excessive amounts of water. Remember, the color is in the pigment, not the water. Color is emotional, so take time to think about it before you paint, and then watch what is happening while you are painting. Some planning is good, but over-planning can be fatal. Experiment! The joy of discovery is one of the rewards of the visual arts. Firsthand knowledge is gained only by painting. Don't let the fear of failure rob you of the creative experience.

SIMULTANEOUS CONTRAST

Colors are light or dark, warm or cool. A dark placed against a light usually indicates a change in direction (lights come forward, darks recede). A warm against a cool often indicates that which is in sunlight (warm coming forward), changing direction to that which is in shade (receding). A warm against a cool, such as orange against blue, is an aggressive color in direct contact with a recessive color. Orange and blue are complementary colors, which makes this painting an example of simultaneous contrast in its purest form. This push-pull effect communicates loud and clear, and it is referred to as giving the painting a "heartbeat." These contrasts, if not already apparent, need to be created by the artist.

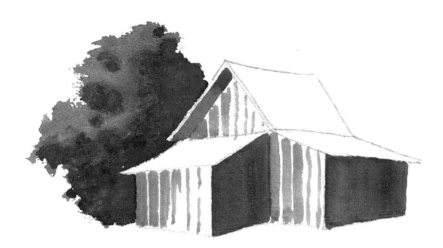

The tree is first painted on the sunny side with light, warm colors. Then cools are added on the side away from the sun. The barn is painted with warm colors in front, and then the sides away from the sun are painted with cools. Notice that the colors begin to warm as they recede from the corners. Look for these transitions from cool to warm, and learn to paint them.

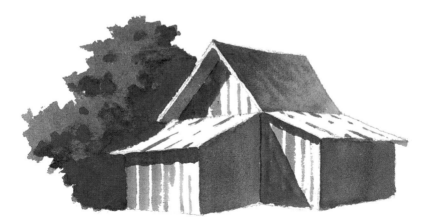

Notice that the blue appears far more brilliant when darks and warms are placed around it. This is called "complementary contrast."

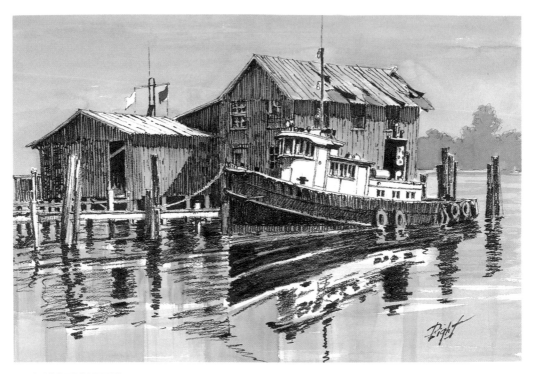

MONOCHROMATIC

The scene above is ideal for black pen and gray wash. After drawing with felt pen, apply an even gray wash overall, except in the white areas. When dry, darken some shapes with the same wash. The scene below was done the same way using a brown waterproof felt pen and a burnt sienna wash.

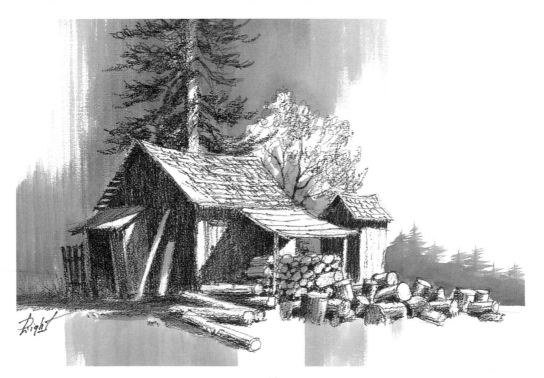

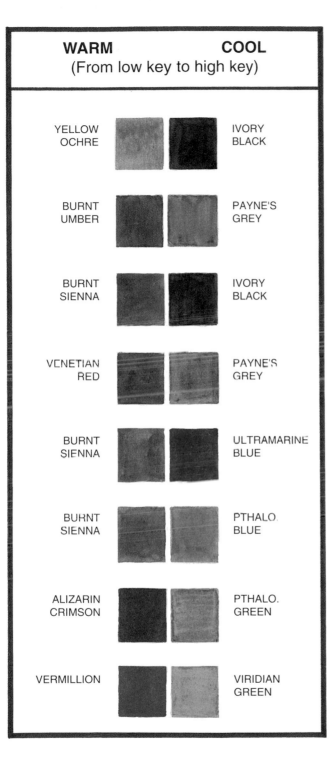

WARM	COOL
WARM	**COOL**
(From low key to high key)	
YELLOW OCHRE	IVORY BLACK
BURNT UMBER	PAYNE'S GREY
BURNT SIENNA	IVORY BLACK
VENETIAN RED	PAYNE'S GREY
BURNT SIENNA	ULTRAMARINE BLUE
BURNT SIENNA	PTHALO. BLUE
ALIZARIN CRIMSON	PTHALO. GREEN
VERMILLION	VIRIDIAN GREEN

TWO-COLOR PALETTES

Many great works have been completed with a limited palette. Using just two colors can show how well you utilize values. Using many colors is purely decorative unless the colors are supported by the elements of design: line, shape, value, texture, size, and direction. I have often said, "A lot of color will not make a bad drawing good." When painting with a limited palette, it is easier to remember warm against cool and light against dark, and a pleasing color composition is more likely to result. It is easier to keep color composition from getting out of hand when using only two colors. Many artists are good at drawing, but fearful of applying color. Starting with a two-color palette will help you gain confidence. (See examples in the gallery, pages 58-64.)

Some artists you may be familiar with who have done wonders with a limited palette are Phil Dike, Rex Brandt, and Robert E. Wood.

STEP 1

This old barn in Big Bear, California provided an opportunity to learn many things. The sketch is vertical because it worked best that way. The format—vertical, horizontal, or square—is best determined by the subject. For instance, if the subject is tall and those things at the left and right sides are of little or no importance, most of the space on a horizontal sheet would be wasted with sky and trivia, making the main subject smaller than it would be on a vertical. On a vertical it can be more dramatic. Conversely, most landscapes fit on a horizontal format.

BURNT SIENNA

ULTRAMARINE BLUE

STEP 2

The shadows on the building and the shapes of the rocks were penciled in before using the felt pen. Follow the direction of the surface of the objects when inking in the drawing. Pay particular attention to white shapes. As a rule, shadows are darker and colder than shade. Shade is warmer and lighter than shadow.

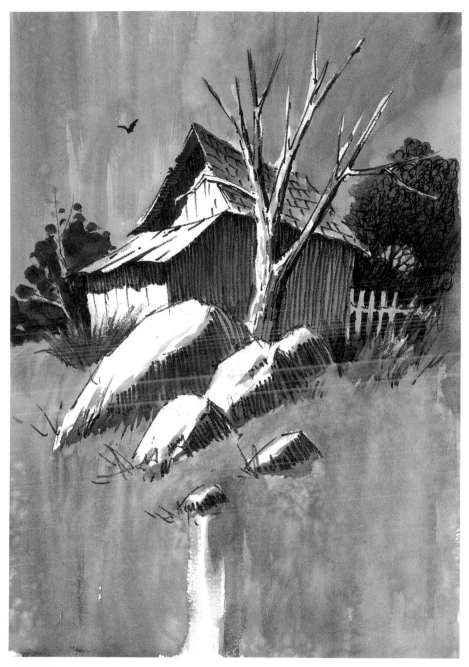

STEP 3

A warm (burnt sienna) and a cool (ultramarine blue) are used for this piece. These two colors can be mixed to produce black, neutral gray, and an infinite range of cool and warm grays. First paint the ground, then the sky. Follow the rules for simultaneous contrast when painting the shapes of the barn. After the big shapes are completed, add the details and calligraphy necessary to finish the painting.

49

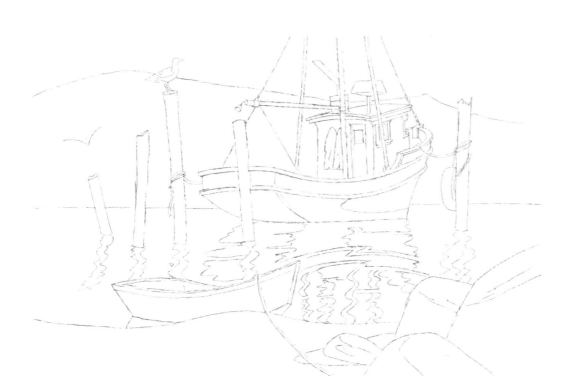

YELLOW
OCHRE

ALIZARIN
CRIMSON

PTHALO.
BLUE

On pages 28 and 29 we began to consider counterchange and relationships. On the following pages this process will be brought to a conclusion. **Step 1:** Sketch the arrangement on a half-sheet of rough watercolor paper; then make final adjustments. Make sure the mast does not go out of the top center and that all of the pilings are different heights and do not stand perfectly straight. **Step 2:** Now the felt pen is used. Consider shapes, shadows, light and dark patterns, and counterchange. The sand in the foreground is yellow ochre and alizarin crimson. Some water is splashed in by hand while the color is wet. Practice this; it creates different textures with a degree of dryness and different colors. The mountain is textured in the same manner. **Step 3:** Just three colors are used in this painting: yellow ochre, alizarin crimson, and pthalocyanine blue. When painting, remember that warms and lights usually advance and cools and darks usually recede. Millard Sheets often said, "Remember, sky, water, sand, rocks, and boats are made of different stuff; consider this when texturing these areas."

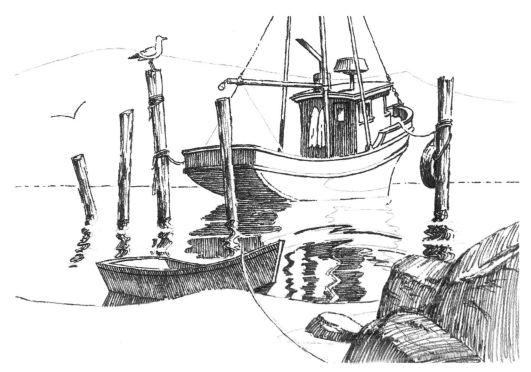

Remember, the sky and water are related, but they are not the exact same color.

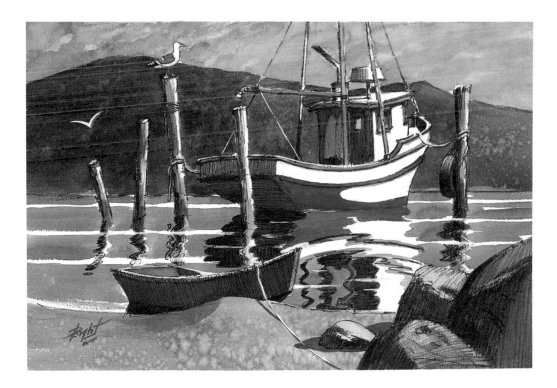

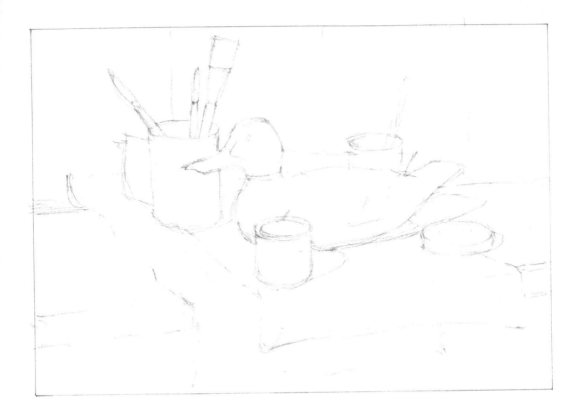

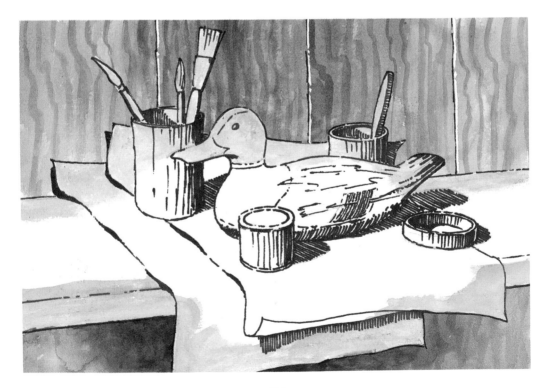

STILL LIFE

I have never done a still life without learning something. It seems like we can see and feel the fundamentals better when we're close to the subject and can handle it. **Step 1:** Move the objects around until you are pleased with the arrangement, and then begin the sketch. (Sketch lightly in case you want to make a change.) **Step 2:** Once the elements are in place, begin drawing with waterproof felt pen; pay attention to the shapes and shadows. Then apply liquid mask over the areas shown in yellow. This will protect the area so the top area (boards) can be painted, textured, and worked over with a grain indication without worrying about the whites. Also, the bottom area is painted in at this time with pthalo. green, yellow, and red; it is textured by dripping water into the wet wash. **Step 3:** This piece was painted with four colors: cadmium yellow medium, ultramarine blue, pthalocyanine green, and cadmium red medium. The top background is painted with a mixture of ultramarine blue, cadmium yellow,

and cadmium red. After the paint is thoroughly dry, remove the masking material with a rubber cement pickup. Now you have clean white paper to continue on. Next, paint the duck and then the surrounding objects. The shapes in the paper were painted with a mixed neutral gray of yellow, blue, and red combined. The printing on the newspaper was done last. With the light coming from the left, paint light to dark and warm to cool. The texture is created by dripping water into the wet color. The remainder of the painting is painted light to dark and warm to cool.

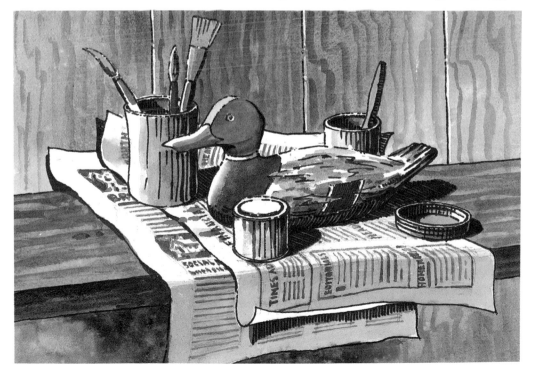

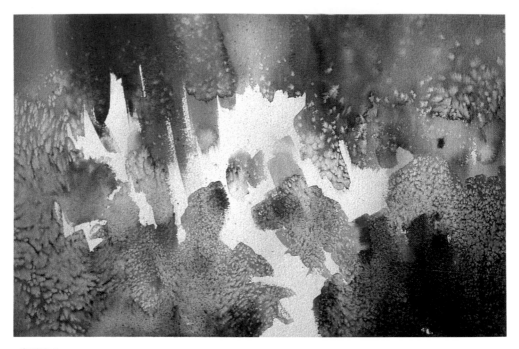

STEP 1

The basic plan for this background is to leave areas of white and create textures. It is painted very rapidly, then while still wet, water is dripped into the sky color, and salt is sprinkled into the wet paint on the bottom half.

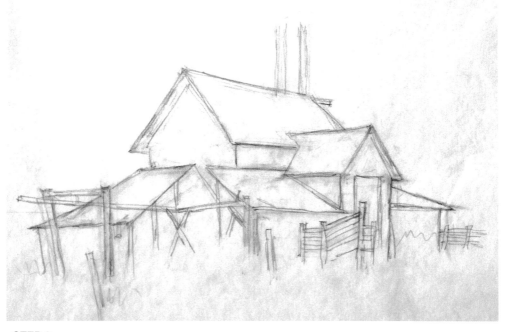

STEP 2

Once the paint is thoroughly dry, brush off the salt. Use pencil for the sketch. You can erase, if necessary, without damaging the color.

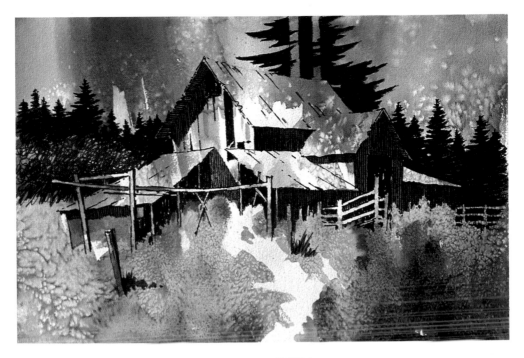

STEP 3

Keeping in mind that the light is coming from the upper left, use felt pen to outline everything on the side away from the light. Next, do the trees in the background, both left and right. Leave the color that is there for the trunks of the two pine trees on top. Do all shaded areas, being careful to leave any fence or bushes untouched. The area under the eaves and all shadows are then done; the blacks are added last. Do not fill in the blacks too solid. Leave a little light in areas so the blacks do not look like holes in the paper. This is fun because it pulls the barn into focus, leaving the exciting colors and whites on the subject. Do only what is necessary to define the subject.

STEP 4

After the pen work is completed, strengthen the color in the shade and shadow areas with the same colors you started with for the background. I didn't introduce new colors at this time because I wanted the overall effect to be more interesting than a typical barn painting.

Do not overpaint! Keep your paint as transparent as possible. Apply colds and warms into the shade and shadow areas. Variation will keep them from being boring. Whenever possible, put light against dark and vice versa. The background and the subject matter will become integrated. The fewer details the better, for example, the few lines indicating roof surfaces. Leave as much of the original background as possible. Practice painting different backgrounds.

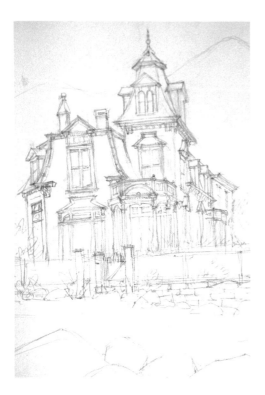

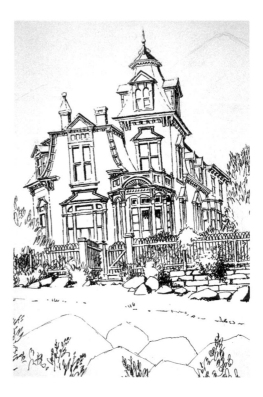

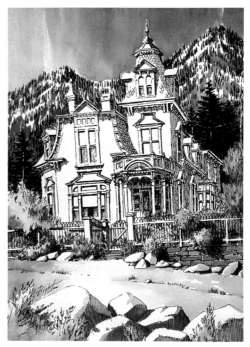

The Maxwell mansion in Georgetown, Colorado is considered by many to be one of the outstanding Victorian houses in America. **Step 1:** The sketch is important for determining placement, format, and the amount of detail necessary. **Step 2:** Apply the felt pen, but try to avoid outlining too much, especially on the light side. Pay careful attention to the areas of great detail: how much should be included? how complicated should it be to create the impression of intricate design? Use felt pen to practice drawing some of the scrollwork on scrap paper. Remember, simplification is very important in the art world. **Step 3:** Nature is never easy, so begin the watercolor washes to set a fall mood. The mountains have color, but the white is left for the snow. Using the edge of a one inch brush in an up-and-down motion, quickly move across the mountains to leave the whites in a random arrangement.

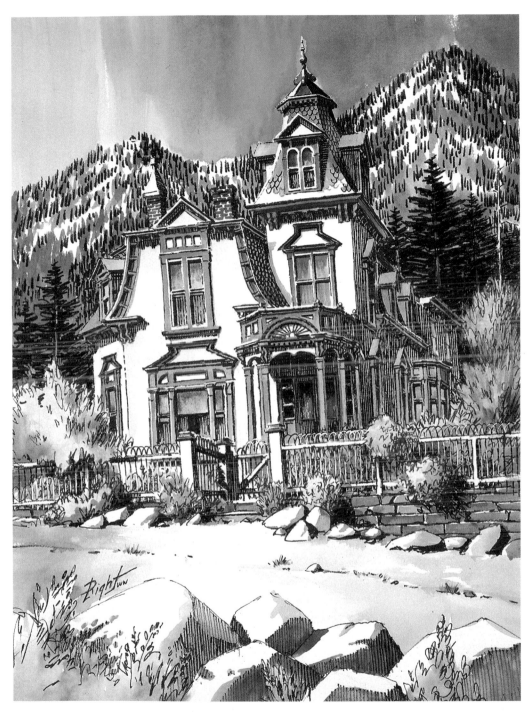

STEP 4

Apply purple (related to the sky) on the shaded sides of the house. Use the same blue as in the sky for the dormers on the side. Paint the trim with a warm from the sky; later, use a burnt sienna to strengthen the shape. Use color from the sky on the roof and the foreground rocks. Rex Brandt calls this technique "cross-pollinating." It gives the painting a feeling of unity.

Gallery

American Heritage
Grape Day Park in Escondido, California has provided subject matter for many plein air workshops. The subjects were rearranged for a more interesting composition. The vertical was dictated by the windmill and a closer look at the subject matter. *Private collection.*

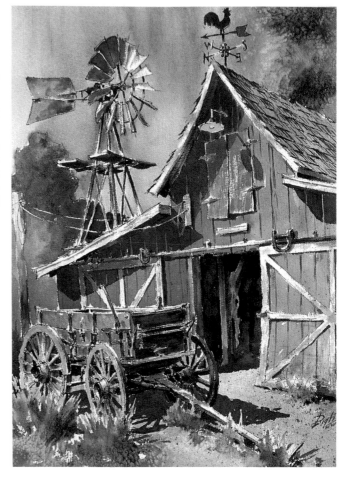

The Madelyn G
Afternoon sunlight, beautiful sky, and dark reflections in the water provided an interesting composition. If possible, view your subject at different times of the day. Also, consider weather conditions that may enhance the mood. The sketch was done on location; pen and watercolor were added later in the studio. *Private collection.*

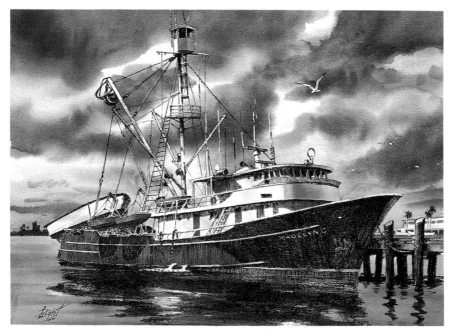

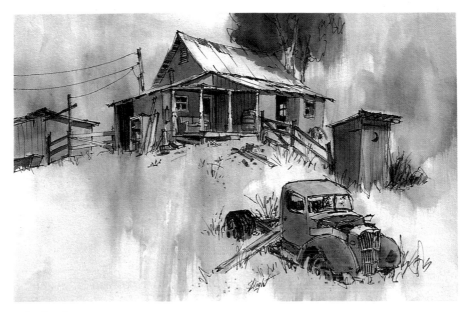

Outback

To record this old ranch, the vertical strokes in the background were painted and allowed to dry. Then the subject was drawn with felt pen and, finally, painted with a limited palette (burnt sienna, alizarin crimson, cobalt blue). *Private collection.*

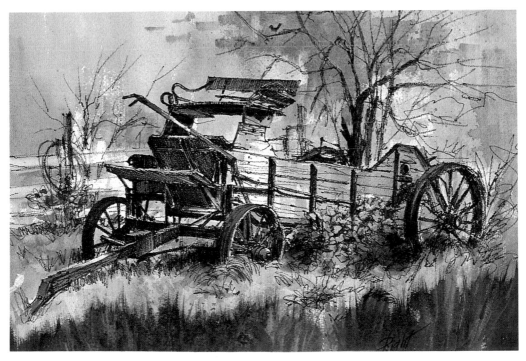

Declining Years

A closeup view can be interesting because the subject's texture is more visible. A low viewing angle and attention to character made this old spreader a fine bit of recorded history. *Private collection.*

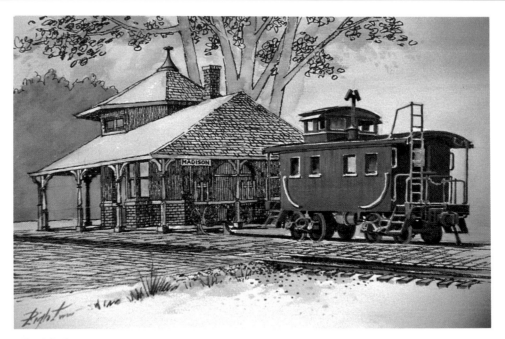

Red Caboose
The old caboose was handled poster-style to contrast with the Madison, Indiana depot, which allowed the caboose to dominate the painting. *Collection Sandy Bishop.*

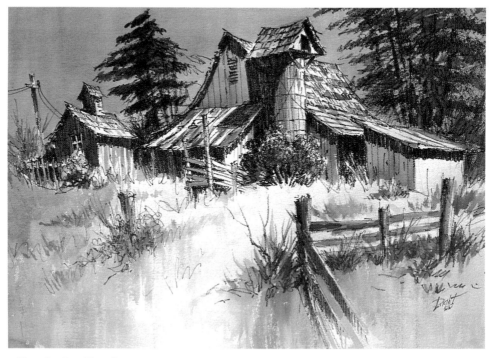

Mendocino Rural
Old barns and silos offer a lot of character, texture, and color. A limited palette of burnt sienna and ultramarine blue were used here. *Collection David Logsdon.*

Old Timers
The drawing was done with felt pen, then the vertical strokes of the background were added, balancing the cobalt blue and burnt sienna with a few white areas. *Collection Joe and Glenda Bernard.*

Northern Harbor
Mood was the most important factor for painting these fishing boats in the morning light. The contrast of the pen worked well with the limited palette of pthalo. blue and a touch of Indian red in the sky and water. *Private collection.*

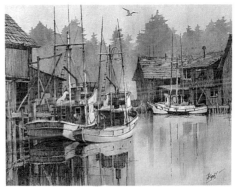

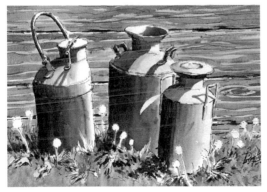

Reminders
These milk cans are from a collection of antiques owned by Dr. Winchester of Hannibol, Missouri. Moving in close when you're working outside can be very rewarding. Take photos when light and shadows are best. *Private collection.*

Steaming Up
Preparing the family steam tractor for the Old Settler reunion is an annual affair at this farm in Michigan. Move the subjects around for the best composition, overlap, and contrast. A limited palette of raw umber, red, and ultramarine blue was used. *Private collection.*

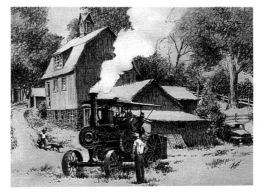

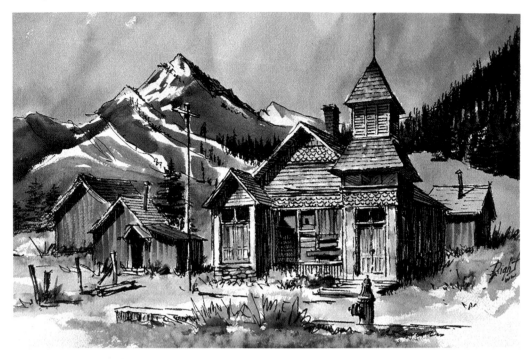

Mountain High Schoolhouse

Boarded up and abandoned, this old schoolhouse in the Colorado Rockies is loaded with character, texture, and history. Warm sky and bright warm colors in subjects suggests a beautiful day in this old ghost town.
Collection Bonnie Engberg.

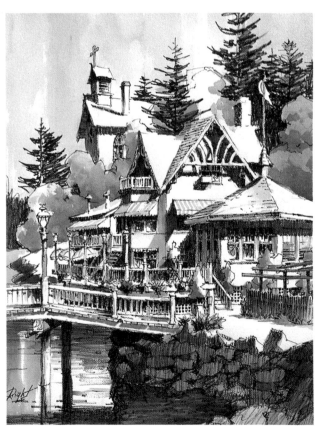

Spiritual Heights

Everything in Rouche Harbor seems stacked up from this angle, suggesting a vertical format. After the drawing was completed with a brown felt pen, a light burnt umber was washed over everything except the whites. This brought the painting to life. A second, darker, wash over the trees, shaded areas and shadows seemed sufficient.
Collection Dr. Paul Brown and Connie.

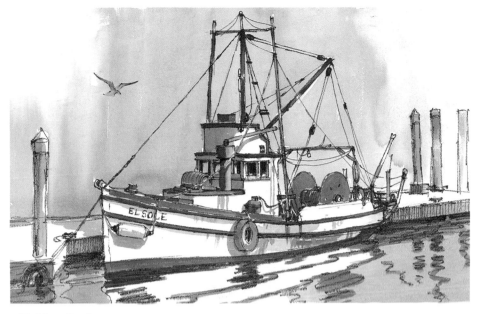

Fishing Boat

Payne's gray was used in the sky and water to outline the boat and the reflection. Burnt sienna for the trim seemed to be all that was needed. *Private collection.*

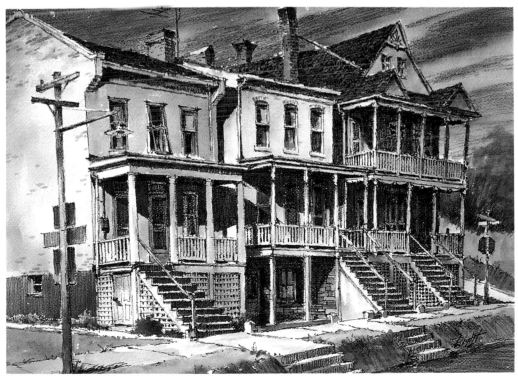

Boarding Houses

These three buildings, from Hannibal, Missouri, are an example of the many architectural subjects that can be done with felt pen and a limited palette. *Collection Jim and Patty Light.*

On the Square

This background is a completed abstract with an exciting texture. It was completed in the studio without regard for subject matter. The house was sketched over the abstract background on location in Sanford, Florida. Shade and shadows were done with felt pen. Subsequent painting on the house and trees was done in the studio. *Collection Lea R. Pare.*

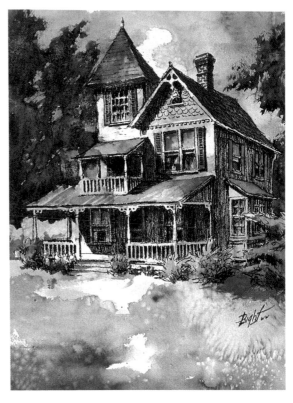

Gold Train

After trekking over the entire length of the bed of this little railroad, I decided to paint the train in action as a gold train coming from Virginia City, Nevada. The town and remains of the mines are still there. Remember to try to tell a story! *Collection Penny and Paul Stanaford.*

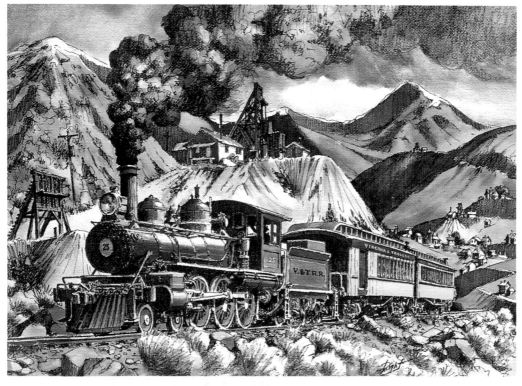